It's Me Denise

Copyright © 2019 by Denise
All rights reserved.

Hi, I am Denise. I am 5 yeasrs old girl from Taiwan.

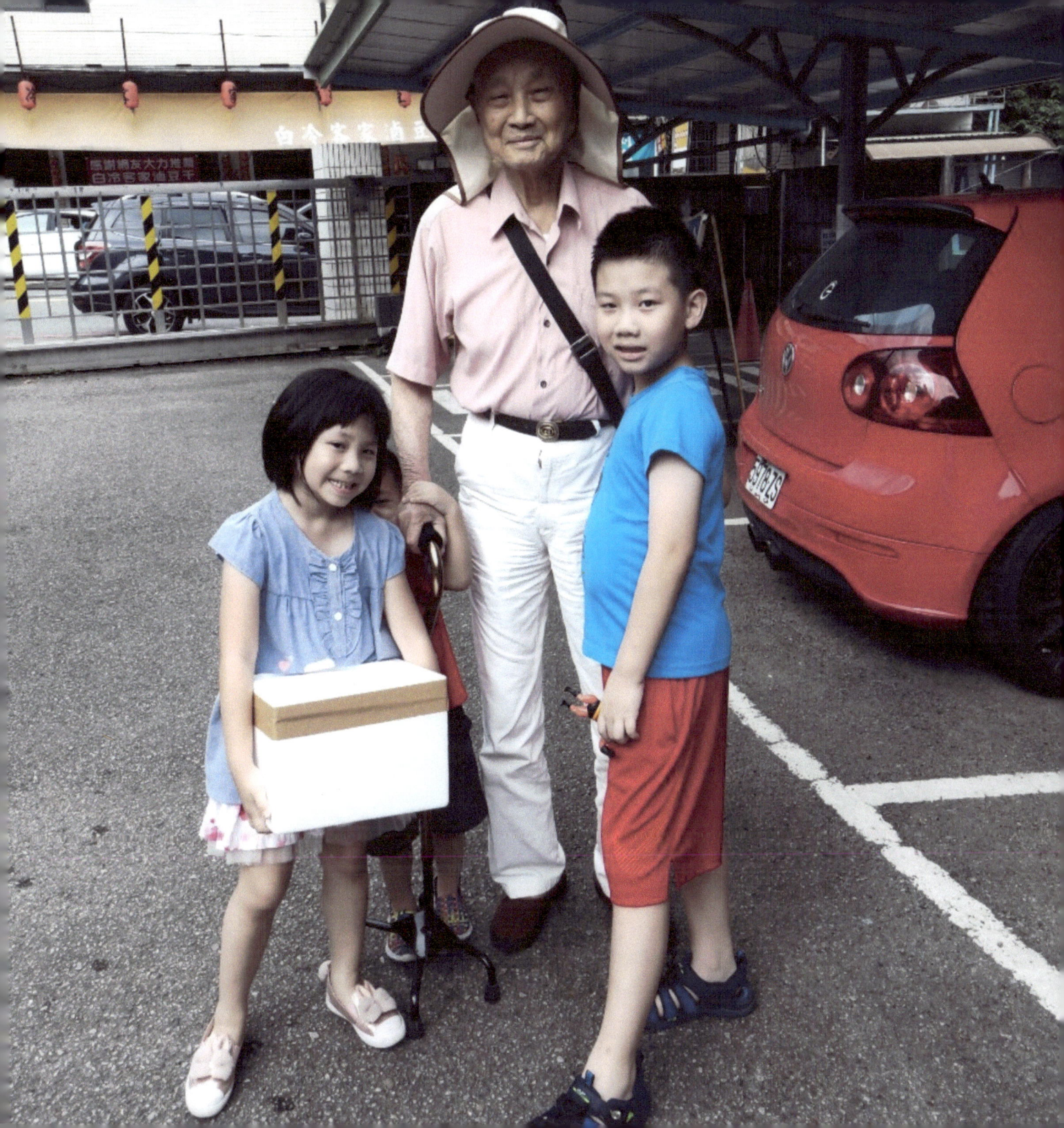

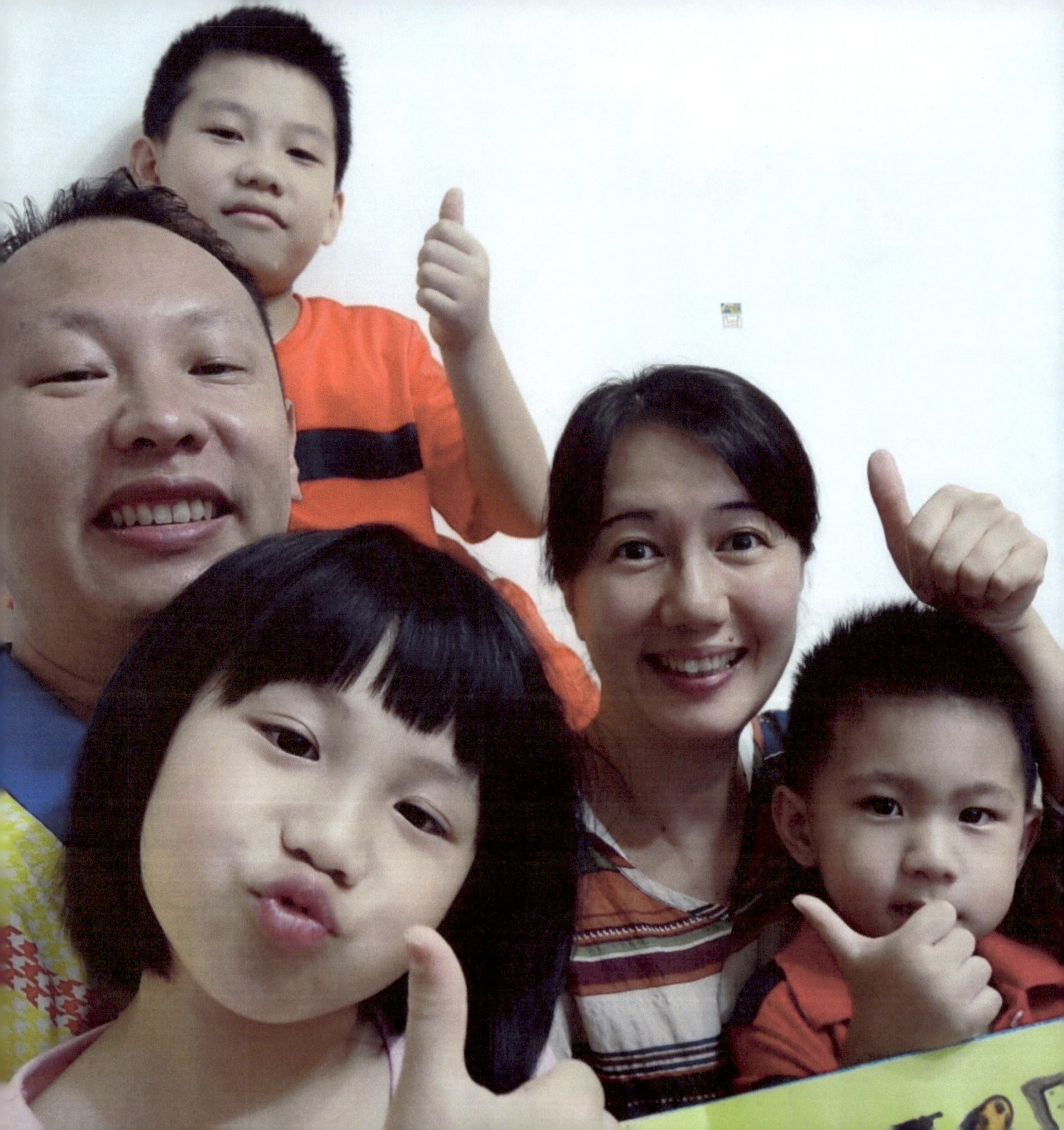

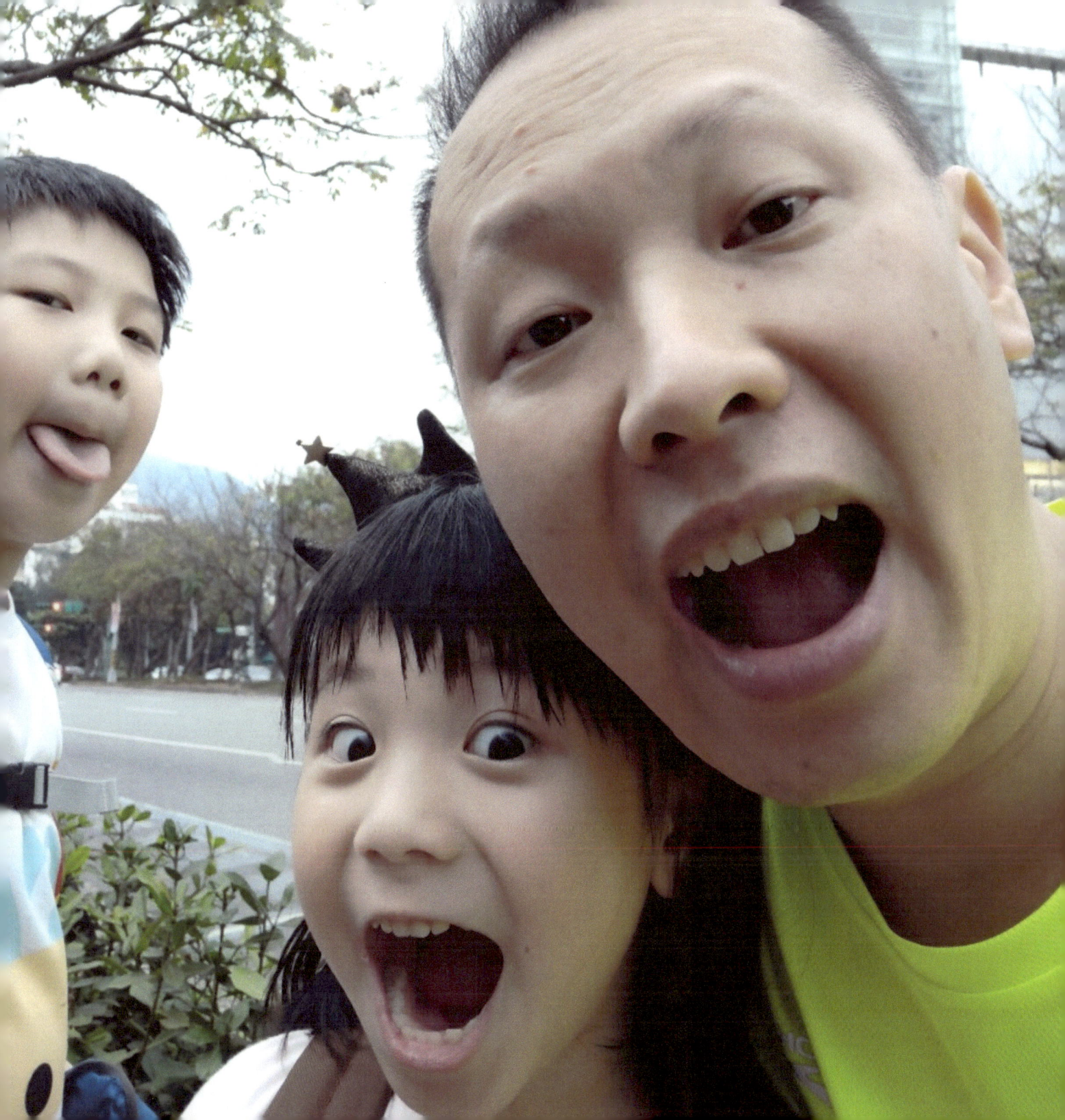

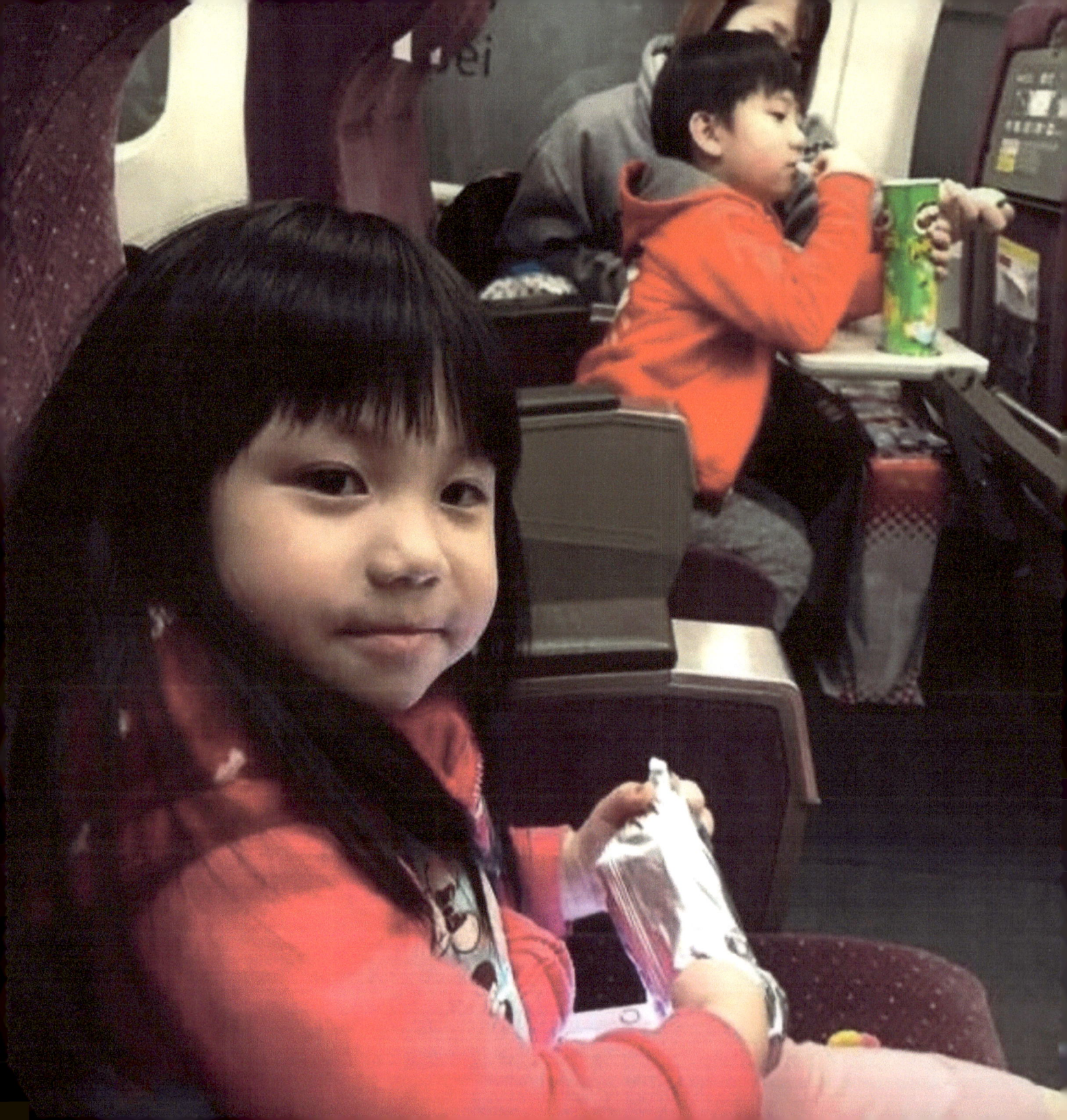

I like to wear cute dresses.

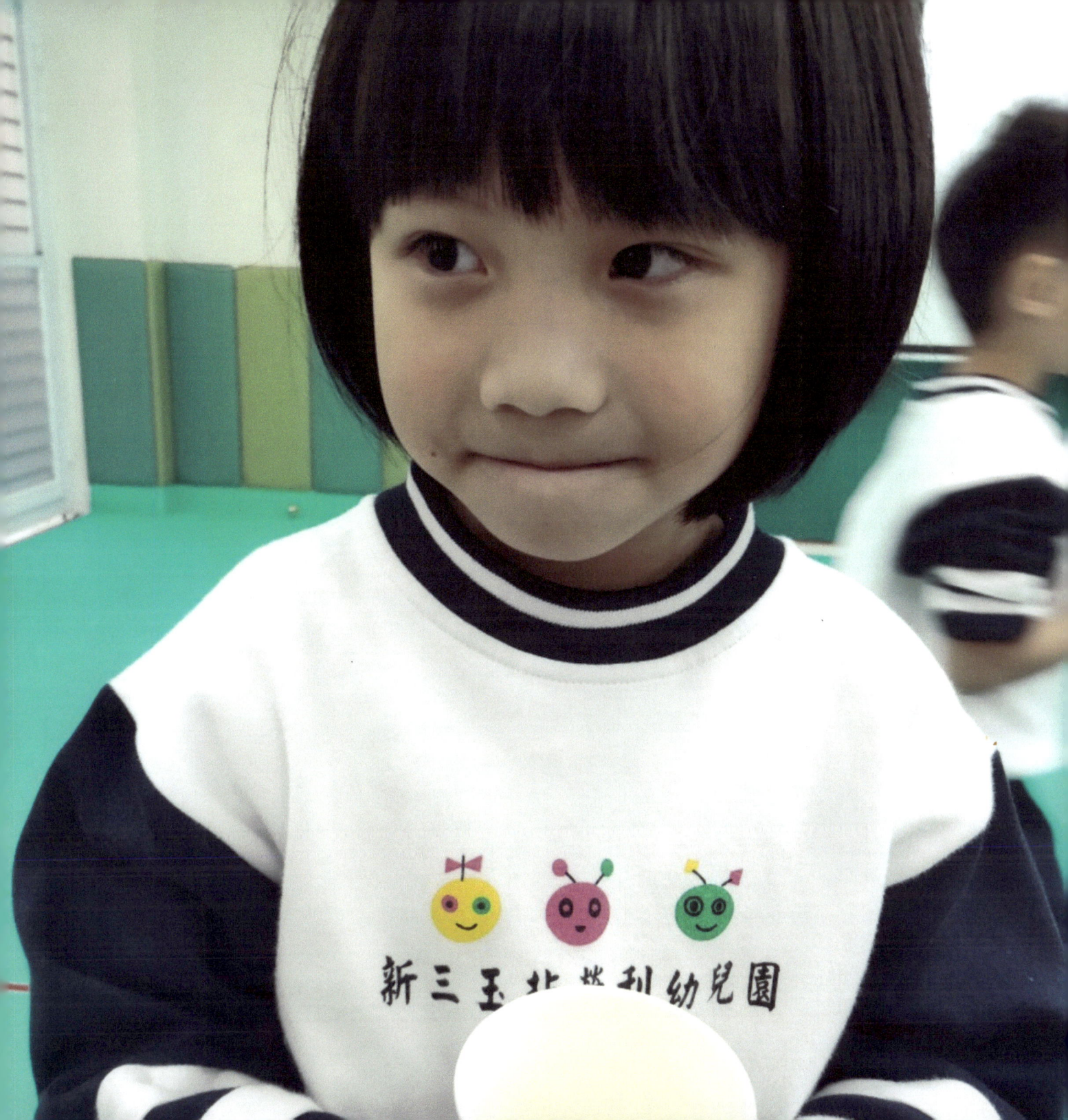

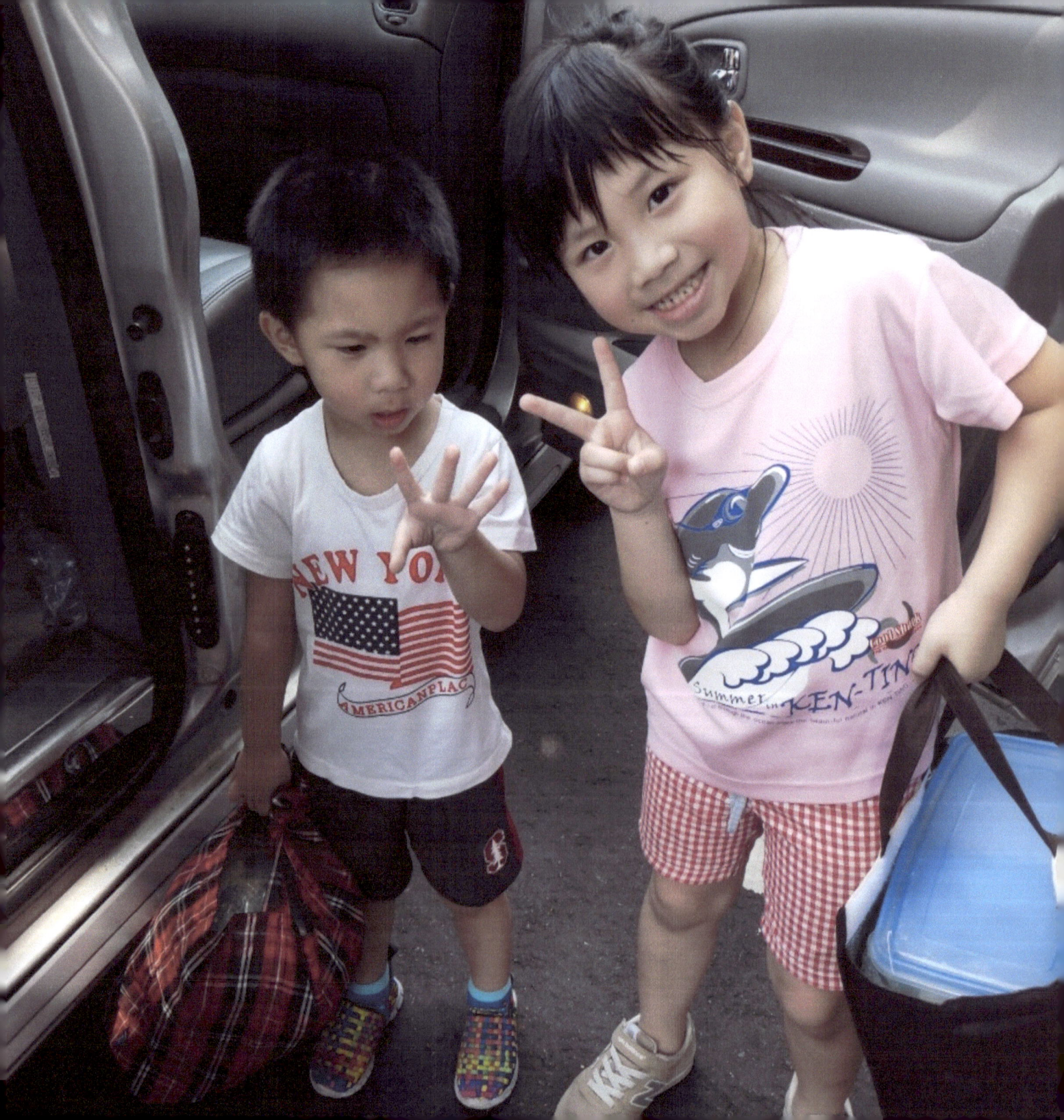

Hi, I like chocolate very much!

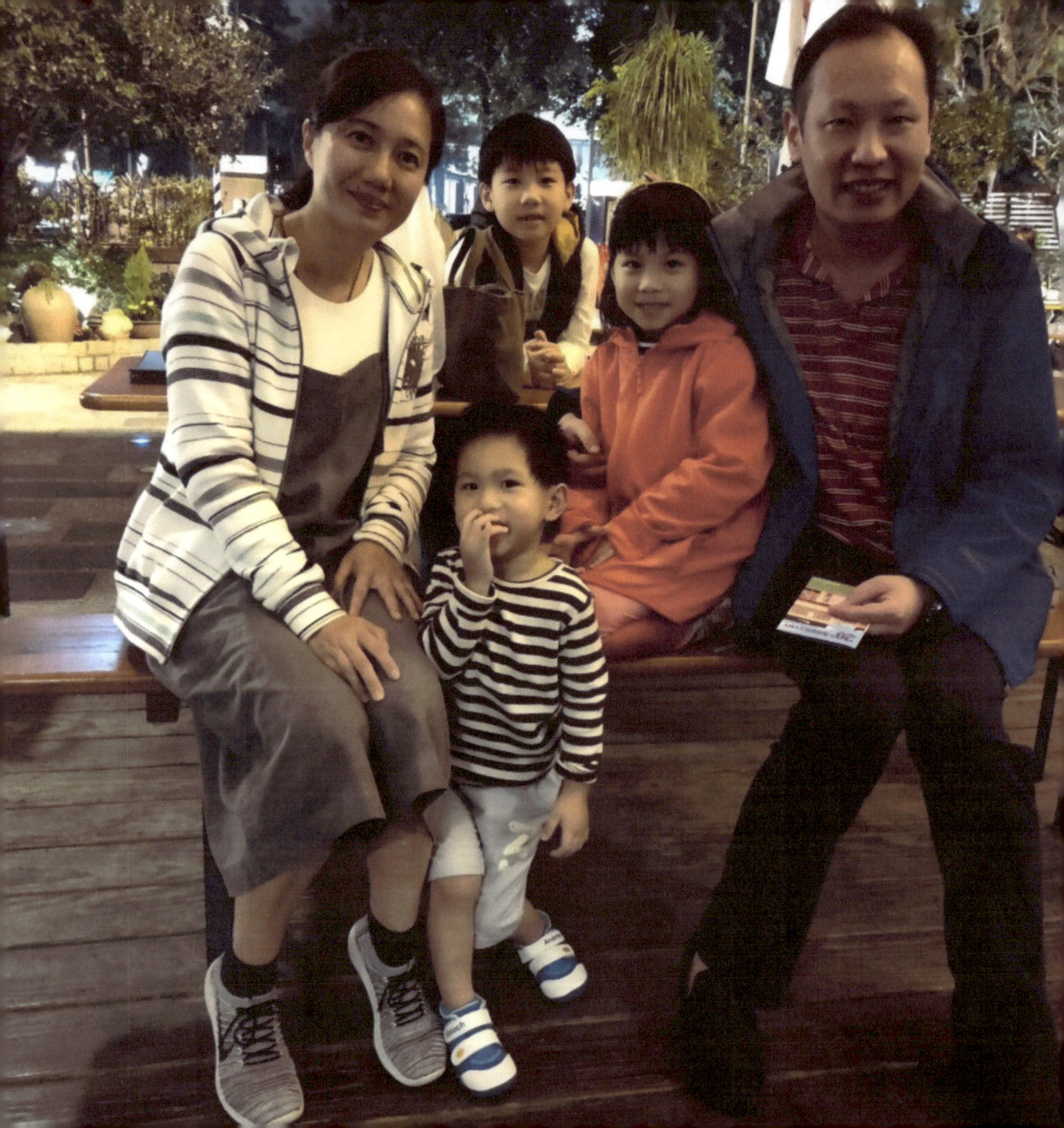

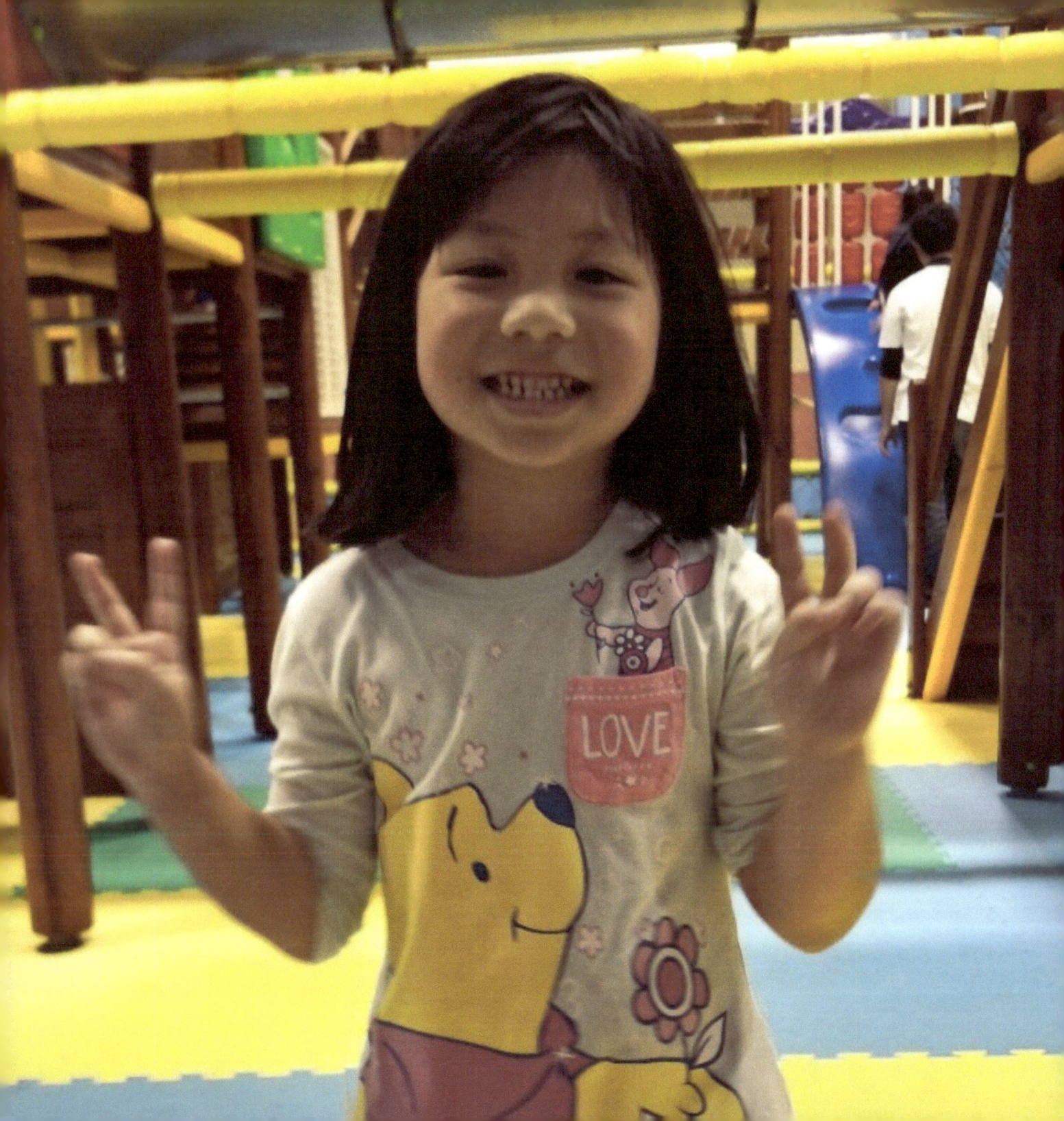

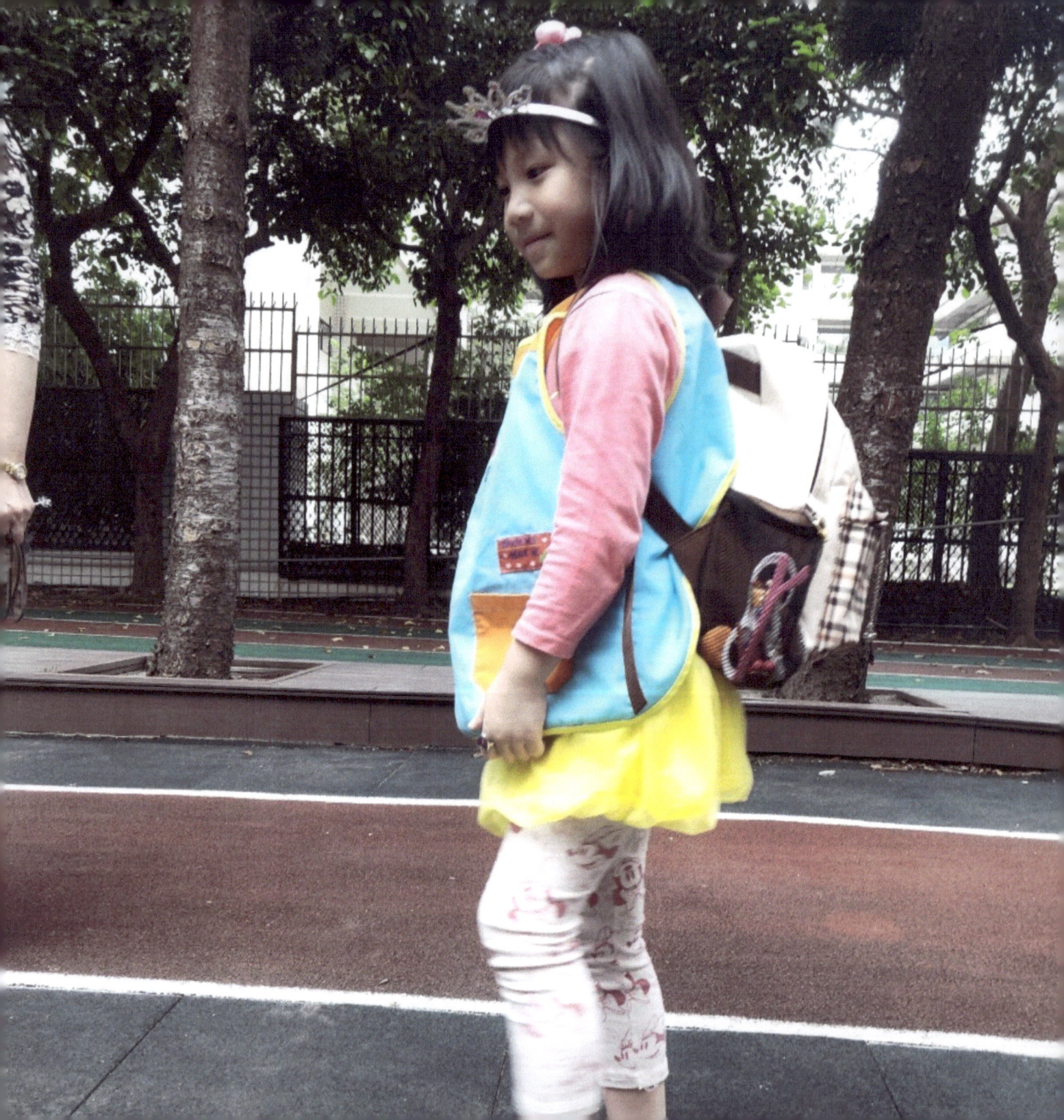

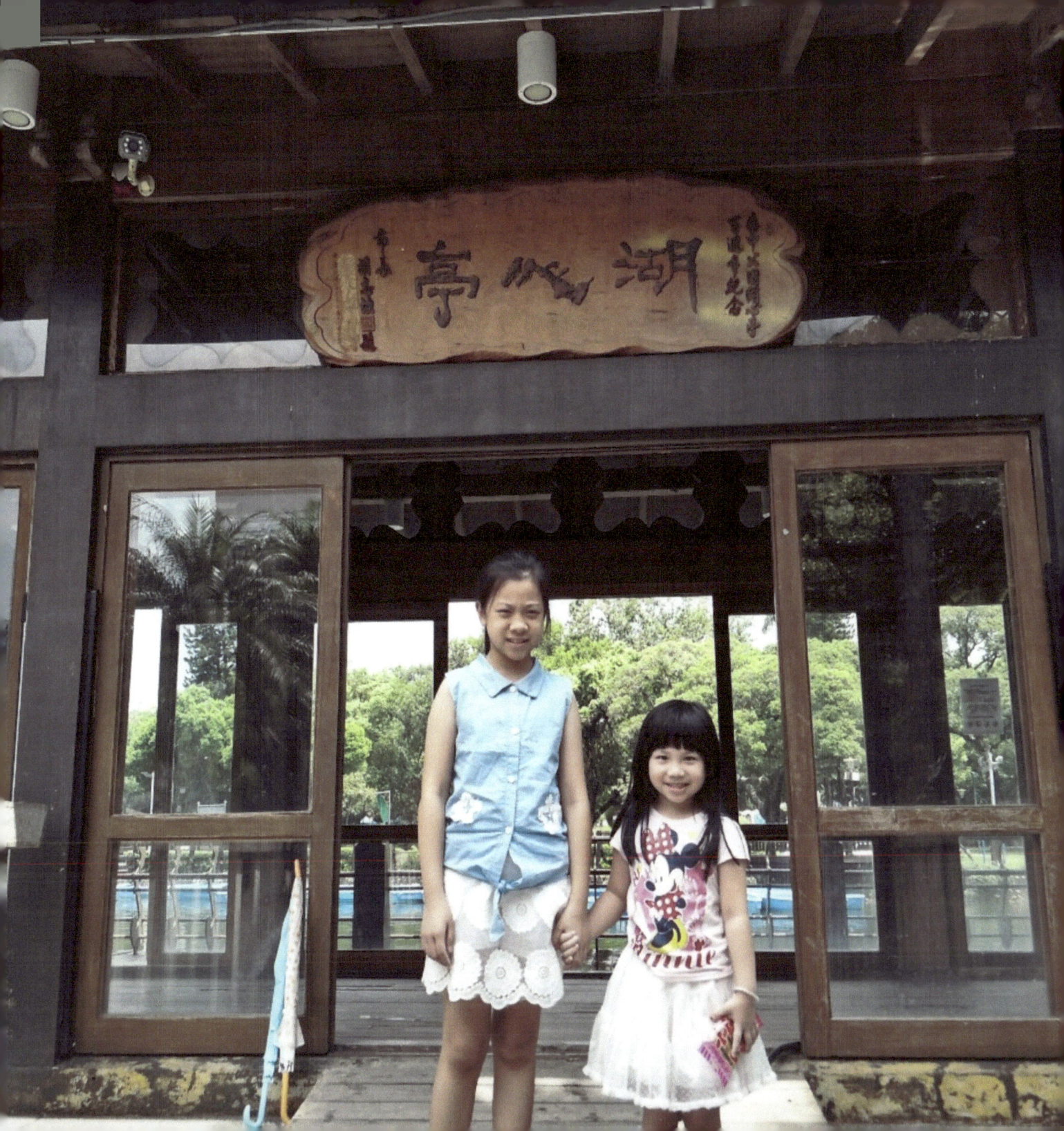

Hi, I like play around with my father!

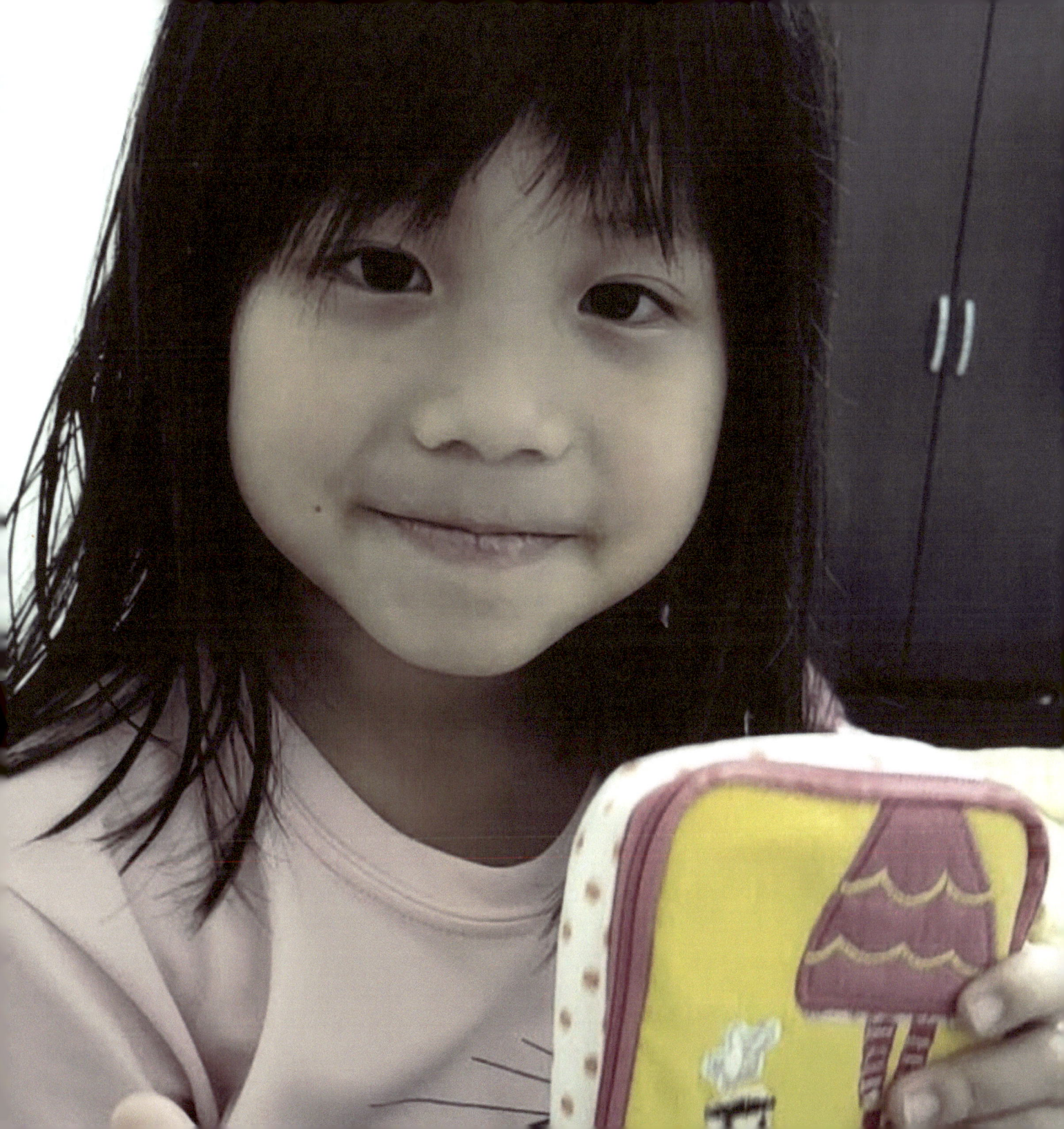

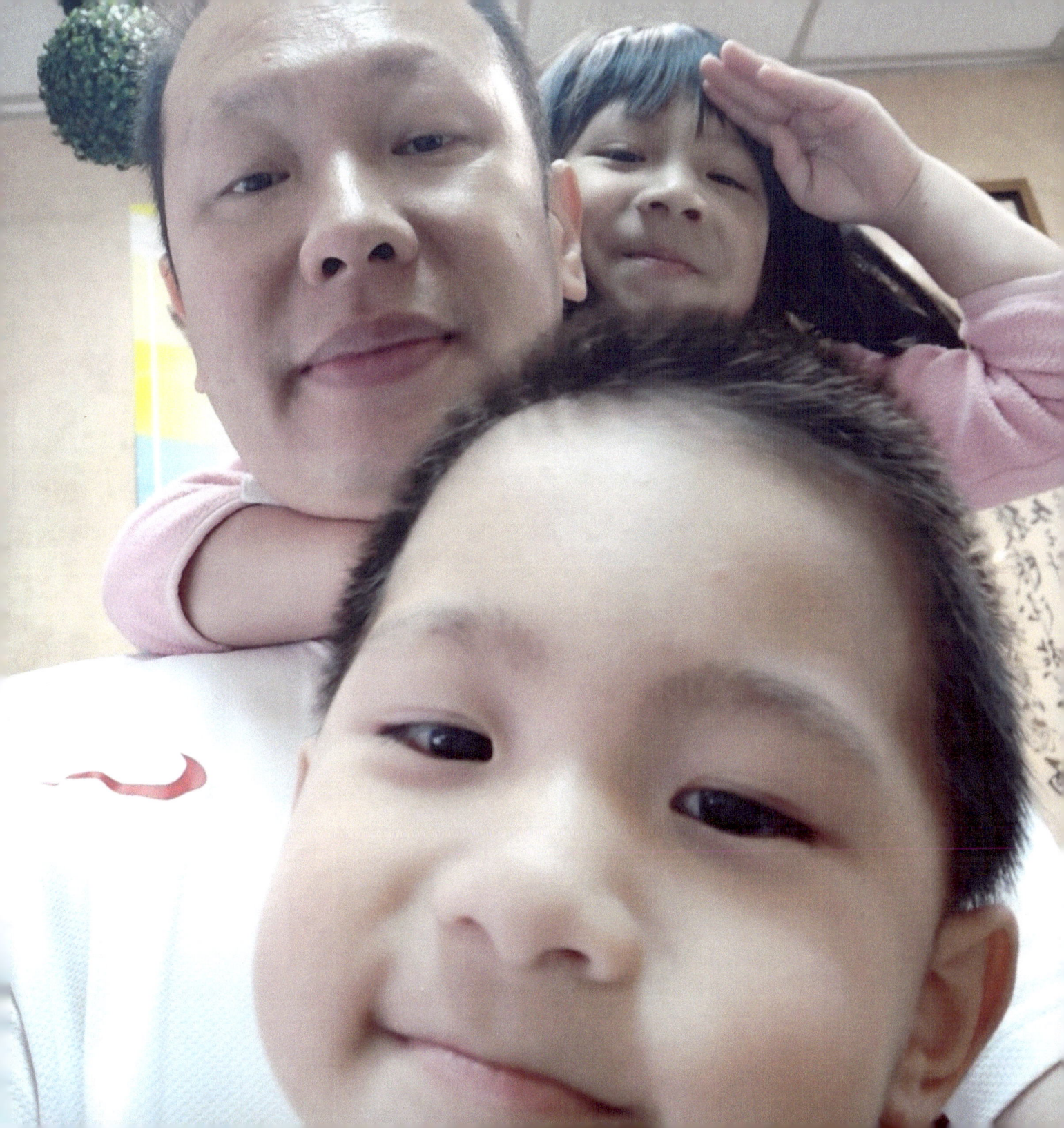

www.ingramcontent.com/pod-product-compliance
Lightning Source LLC
Chambersburg PA
CBHW041308180526
45172CB00003B/1020